CREWE
HISTORY TOUR

Map contains Ordnance Survey data © Crown copyright and database right [2015]

First published 2015

Amberley Publishing
The Hill, Stroud,
Gloucestershire, GL5 4EP
www.amberley-books.com

Copyright © Peter Ollerhead, 2015

The right of Peter Ollerhead to be
identified as the Author of this work
has been asserted in accordance with
the Copyrights, Designs and Patents
Act 1988.

ISBN 978 1 4456 4864 4 (print)
ISBN 978 1 4456 4865 1 (ebook)

British Library Cataloguing in
Publication Data.
A catalogue record for this book is
available from the British Library.

Typesetting by Amberley Publishing.
Printed in Great Britain.

INTRODUCTION

This book has, as its main aim, the task of indicating some of the places of interest and where change has occurred in the town to provide a historical tour of Crewe. Some of the changes have occurred in fairly recent times, which mean that the scenes could be in the memory of people living today. The scenes also provide a good indication of the town's vast history.

This is not a work of nostalgia, rather is it to portray the reasons why changes have occurred in the town. By the use of detailed captions I have attempted to impart a historical context and to include details that are not immediately known. It lies with others to judge how far I have been successful.

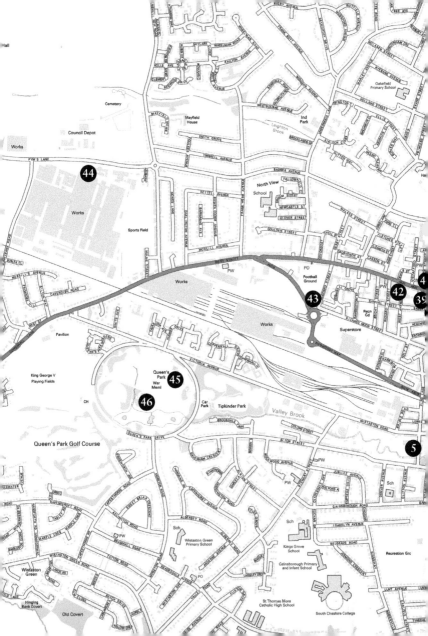

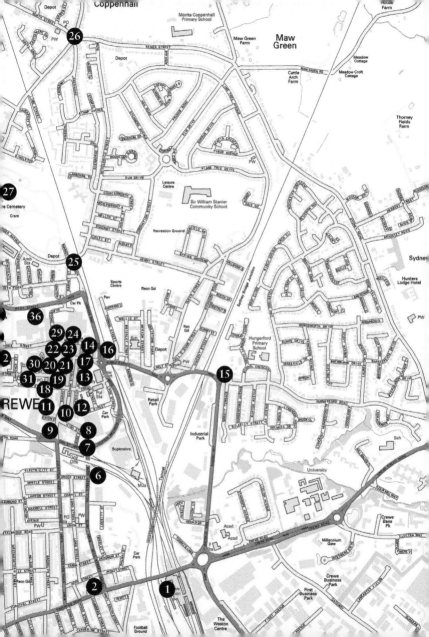

1. CREWE RAILWAY STATION, *c.* 1955

Crewe, as a community, was founded in 1843 to repair steam locomotives in workshops around half a mile from the station. As is well known, a junction of six lines appeared quite soon, bringing employment for motive power workers, in addition to metal working trades of all kinds. By the late 1950s, steam power was being phased out to be replaced by diesel and electricity. The image shows an 8F locomotive hauling a Jubilee class past the station platforms, on its way to the Works.

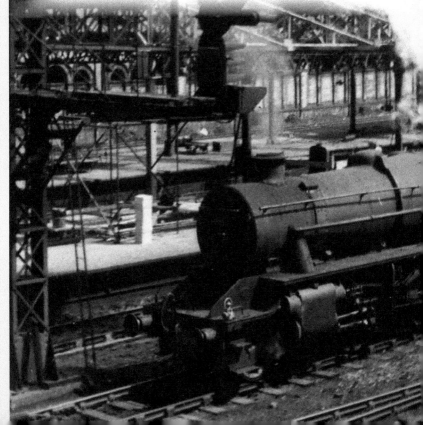

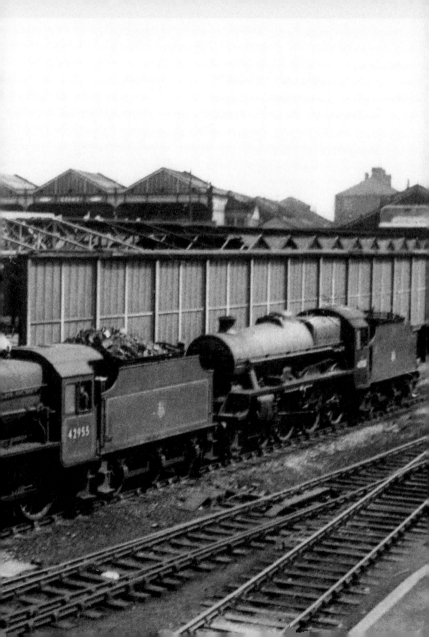

2. LOOKING EAST ALONG NANTWICH ROAD AT ITS JUNCTION WITH MILL STREET, *c.* 1920

Turnpiked in 1816, the traffic passing along this road generated just over £624 in tolls for the Trust in 1865. Not a great deal of change is apparent, though the horse bus has made way for motorised traffic and ladies' fashions have altered. The large building on the south side of Nantwich Road is the Earl of Crewe Hotel, opened in 1897, the year of Queen Victoria's Diamond Jubilee. John Bebbington, the owner, had opposition from Woolf, the Crewe brewer, who wanted to build on the corner of Ruskin Road at the same time, but was unable to obtain planning permission. Many large villa-type residences located in this area of Crewe have been converted into offices, for solicitors and estate agents.

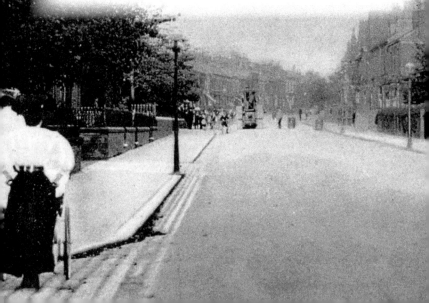

3. THE SECONDARY OR GRAMMAR SCHOOL, RUSKIN ROAD LOOKING NORTH, *c.* 1910

This school is one of the buildings that have changed little over the years since it was opened in 1909. State sponsored secondary education was introduced into the town, in 1902, following Balfour's Education Act. Its first headmaster, H. D. McCurtain, remained in post for over thirty years. Following the 1944 Education Act, Ruskin Road became Crewe's co-educational grammar school, until 1959, when the girls' grammar school was opened in Buchan Grove. Comprehensive education brought the greatest internal change when all ability pupils were admitted in 1978. Ruskin became a college, specialising in sport, after further legislation by Blair's New Labour government, and has managed to stay open when others closed.

COUNTY SECONDARY SCHOOL,

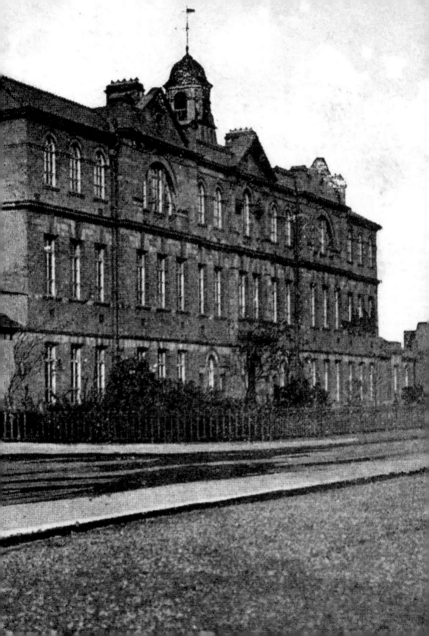

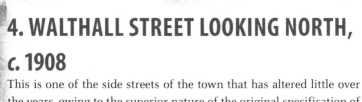

4. WALTHALL STREET LOOKING NORTH, *c.* 1908

This is one of the side streets of the town that has altered little over the years, owing to the superior nature of the original specification of the houses. Built for Crewe's emerging middle class, they have proved capable of modernising, unlike some of the dwellings in the west of the town. Notice that the lamp standards have been removed from the road edge of the pavement to fit snugly against the walls of the house yards. Garages, or parking spaces, were not needed when this street was constructed through the fields to link Wistaston Road with Nantwich Road in 1885.

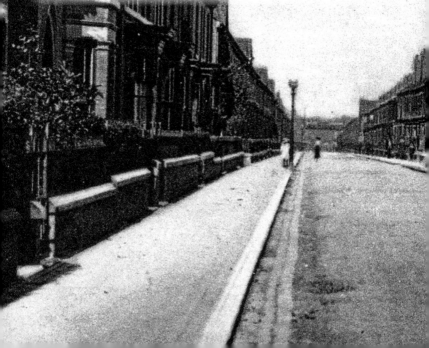

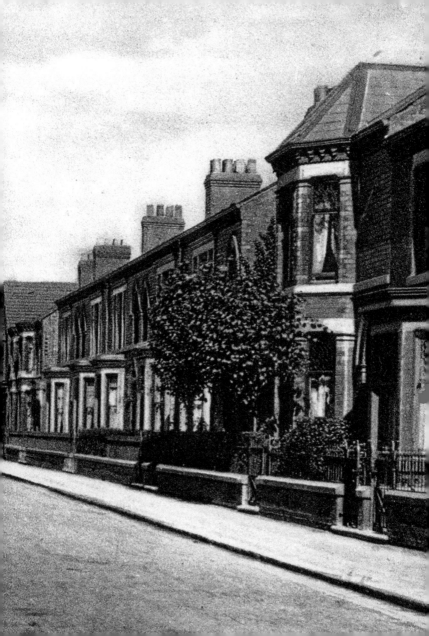

5. FLAG LANE BRIDGE LOOKING SOUTH-EAST, *c.* 1923

In 1923, a government scheme to find work for the unemployed led to the long awaited bridge across the Valley Brook at the south end of Flag Lane. Constructed at a cost of almost £36,000, it was one of the first reinforced concrete bridges in Cheshire and, according to the contractors, Smethurst Ltd of Oldham, would still be in use in the year 2423. The photograph shows the bridge being stress tested by the combined weight of two traction engines. Notice the standard lamps that adorn the walls.

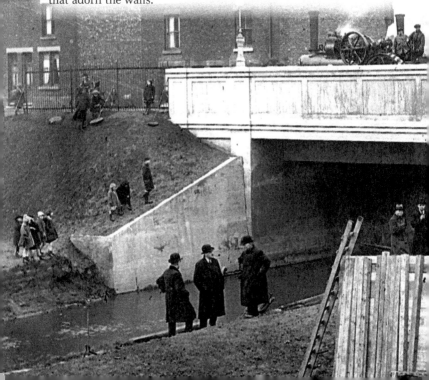

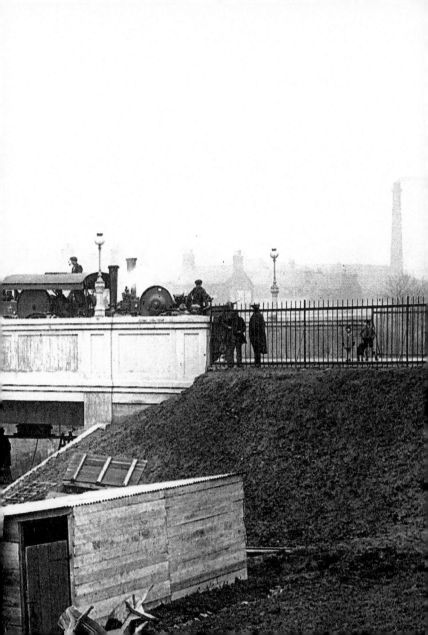

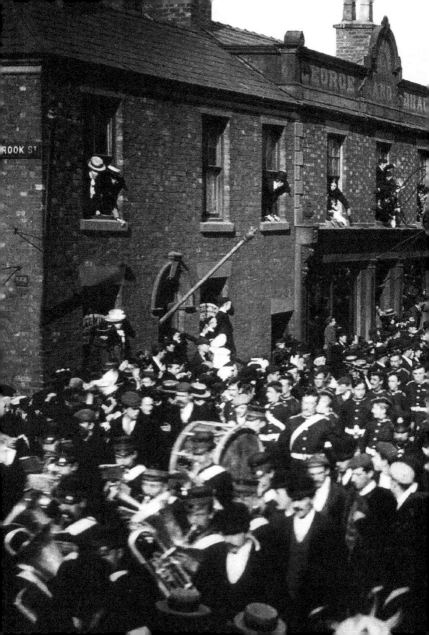

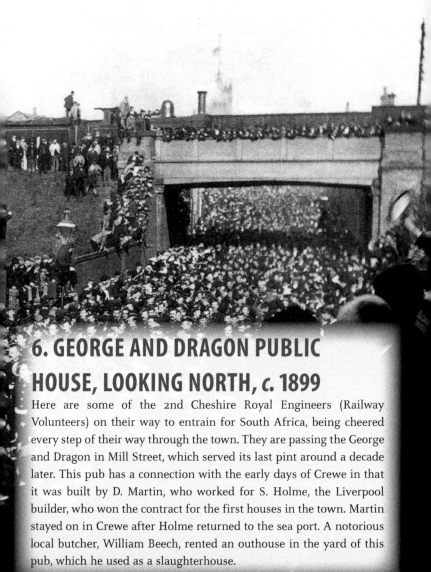

6. GEORGE AND DRAGON PUBLIC HOUSE, LOOKING NORTH, *c.* 1899

Here are some of the 2nd Cheshire Royal Engineers (Railway Volunteers) on their way to entrain for South Africa, being cheered every step of their way through the town. They are passing the George and Dragon in Mill Street, which served its last pint around a decade later. This pub has a connection with the early days of Crewe in that it was built by D. Martin, who worked for S. Holme, the Liverpool builder, who won the contract for the first houses in the town. Martin stayed on in Crewe after Holme returned to the sea port. A notorious local butcher, William Beech, rented an outhouse in the yard of this pub, which he used as a slaughterhouse.

7. OAK STREET LOOKING WEST, c. 1955

As Oak Street is now an integral part of the town's 'improved' traffic flow scheme, its west junction, with Edleston Road, is controlled by lights. Formerly, it was part of a one-way system, in tandem with High Street. The property in course of demolition, though dating from the early years of the colony, was built privately and not by the railway company. On the right were Blackberry Street and Cross Street, both with infamous reputations. In the distance is the chimney of the LNWR joiner's shop that was built upon land released by diverting the Chester line. When John Hill's market hall was purchased by the Local Board the railway volunteers that used to drill there had to use the upper storey of the LNWR saw mill, near to this building.

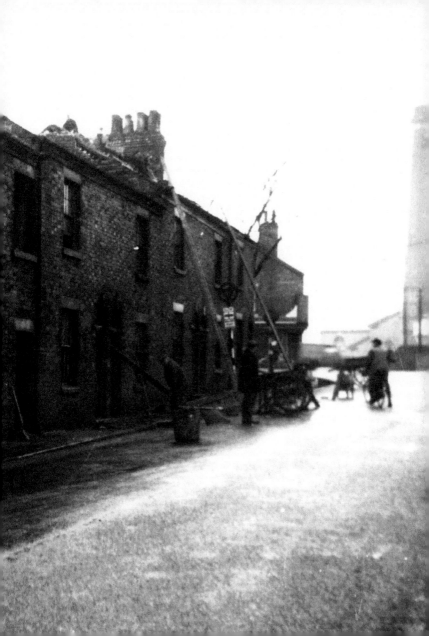

8. JUNCTION OF HIGH STREET AND MILL STREET, *c.* 1890

For most of the twentieth century, the premises that housed Lowe's garment shop were taken over by the *Crewe Chronicle* and used as editorial offices. Previously, it had been published from a couple of rooms adjacent to the Market Square. Two shopkeepers, James Briggs and William McNeill, both Liberals and religious Nonconformists, were responsible for persuading the *Chester Chronicle* to publish an edition in Crewe to rival the Tory slanted *Crewe Guardian*. A young man, Frederick Copplestone, was sent as the first editor in 1874. One of the early photographers in the town, William Moon, had premises in High Street, as did John Kay, a chemist, who kept live snakes in a glass case in his shop.

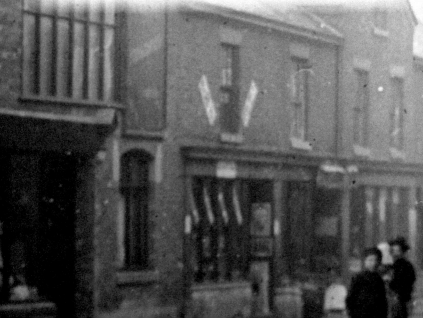

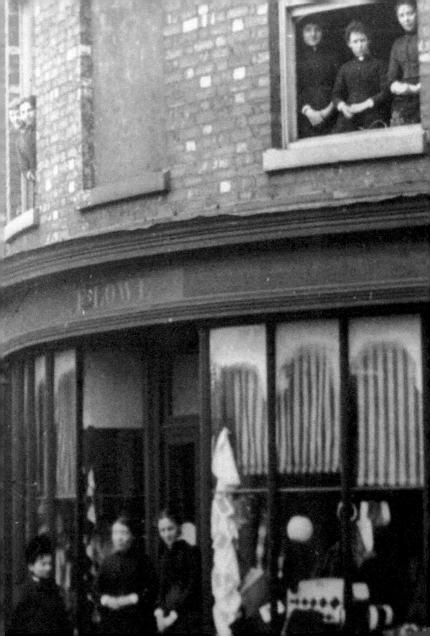

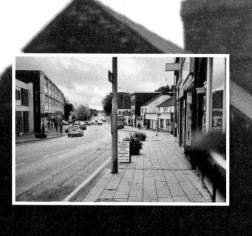

9. EDLESTON ROAD LOOKING SOUTH TOWARDS THE VALLEY BROOK, *c.* 1950

When the town was in its infancy, this road was known as Oak Street, as Edleston Road did not exist. Around thirty years into Crewe's history, when a new name was needed for this section, the Local Board rejected Temple Street in favour of Exchange Street. Eventually, in 1919, it was changed again, this time to Edleston Road to allow the entire road, from its junction with Nantwich Road to Chester Bridge, to have the same name. Exchange Street was a notorious bottleneck once motor traffic began to increase, as it was only 15 feet 9 inches wide between the kerbs. Fortunately it was straightened and widened in the 1950s road improvement scheme.

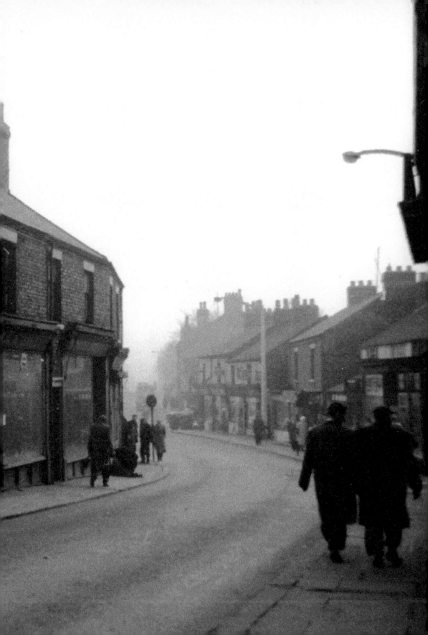

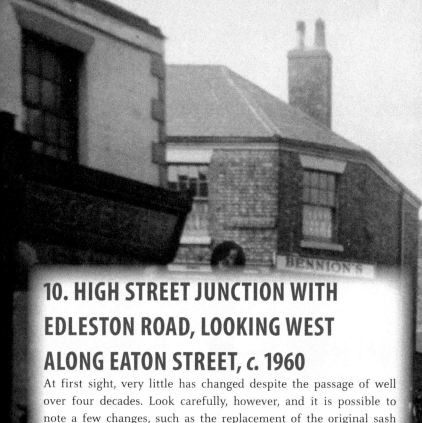

10. HIGH STREET JUNCTION WITH EDLESTON ROAD, LOOKING WEST ALONG EATON STREET, *c.* 1960

At first sight, very little has changed despite the passage of well over four decades. Look carefully, however, and it is possible to note a few changes, such as the replacement of the original sash windows in the upper storeys of the shops on the south side of High Street. Carrington & Button has been replaced by a Chinese Eating House. The proliferation of ethnic restaurants is itself a mark of change in Crewe. At the west end of Eaton Street was the entrance to the Deviation Works, part of the vast complex of LNWR (LMS) workshops, no trace of which now remains. Eaton Street, named after John Eaton, a flour miller and Congregationalist, also contained a railway canteen.

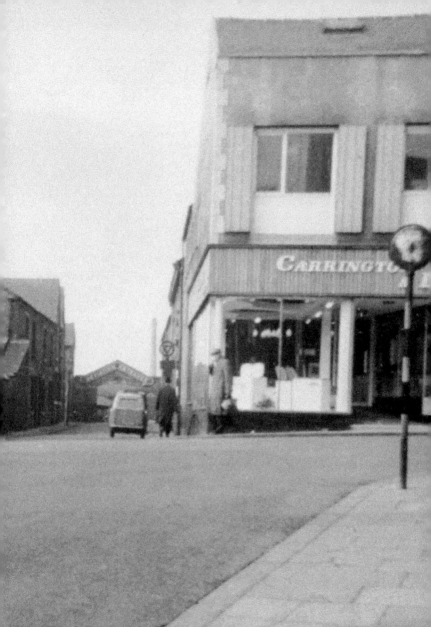

11. COPPENHALL TERRACE LOOKING NORTH, *c.* 1930

For the first half of the twentieth century this stretch of road had domestic dwellings mingled with shops on the east side. Between 1930 and 1953 the traffic on this stretch of highway increased by 187 per cent, meaning that at peak times, in 1953, just over 700 vehicles an hour were traversing Coppenhall Terrace. In addition, some 1348 bicycles per hour were counted in the same census. Despite the obvious need, even before the Second World War, the council's Improvement Plan was only approved by a majority of just over 500 in a town-wide referendum, in 1938. The ornate structure beyond the wallpaper warehouse, on the corner of Chester Street, is the Prudential Building, opened by the earl of Crewe in 1917.

S & H. MORRIS L^{TD}
WHOLESALE & RETAIL
WALLPAPER WAREHOUSE
AGENTS FOR
WALPAMUR — DURADIO
AND VESTA PAINTS.

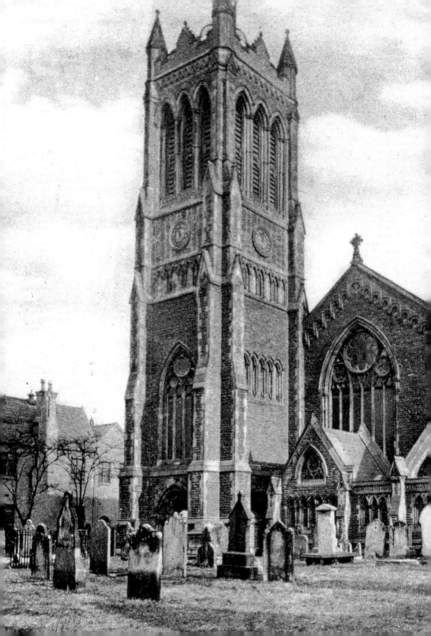

12. CHRIST CHURCH AND SCHOOL, PRINCE ALBERT STREET LOOKING NORTH-EAST, c. 1910

This church, opened in 1845, and the school, one year later, were both at the centre of the Grand Junction colony. Fortunately, for the parishioners, the railway company met most of the cost. A list of the first trustees of the church reads like a roll call of Crewe's first streets, for such names as Gladstone, Moss, and Lawrence are there, along with Trevithick and Allen, as church wardens. In 1852, around 300 children attended this school, only about 25 per cent being boys. Until 1876, when education became compulsory until the age of eleven, the boys only attended for eighteen months on average. By 1960, the school was ready for demolition to allow for the erection of the library and law courts.

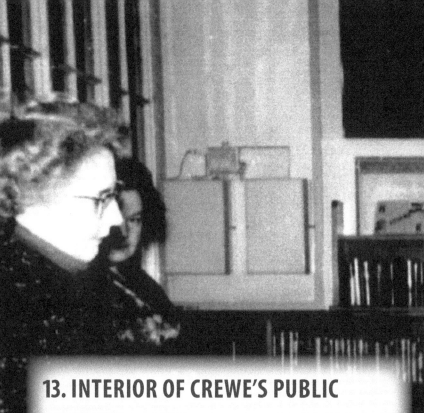

13. INTERIOR OF CREWE'S PUBLIC LIBRARY, *c.* 1955

In addition to changes in the fabric of the town, time also brings alterations in working practices. Here, the chief librarian is in the library, housed in the Mechanics' Institution, using the ticket system for linking borrowed books with the readers, whereas now it is computerised. Today's library provision also includes sessions on computers. Library facilities have been available since 1845, and one of the grumbles of library committees then was that readers preferred light fiction to serious reading.

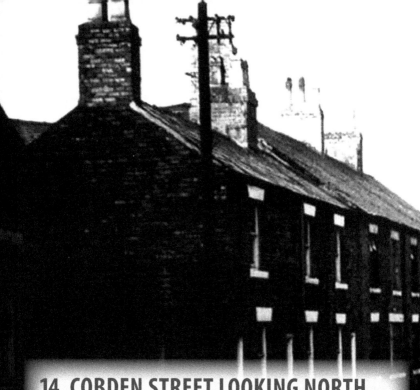

14. COBDEN STREET LOOKING NORTH, c. 1960

Cobden Street, built by Samuel Heath, was named after Richard Cobden, the Manchester Liberal and champion of 'Free Trade'. A bowl on the pavement, on the east side of Cobden Street, is outside of a pet shop. Inside, during the 1950s, was a very fierce parrot. At the north end of the street can be seen a portion of the outside market. Both Cobden Street and the railway sidings, on the west of the Liverpool line, have made way for road widening and an extension to the administrative offices of the Crewe and Nantwich Borough Council.

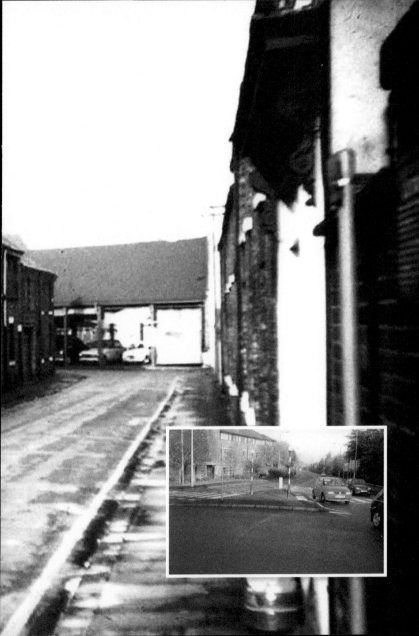

15. HUNGERFORD ROAD LOOKING EAST, c. 1912

Hungerford Road is the continuation of a pre-industrial track that led out of Monks Coppenhall, before the coming of the railway. The attractive terrace of double bay houses has not been subject to many changes. Plastic double-glazed casements have replaced the late Victorian and Edwardian sash windows, while yellow lines keep the road clear of parked vehicles. Other changes include the removal of the telegraph pole when all cables were placed underground. Mrs Hodgkison, author of the delightful *Crewe As It Once Was*, lived at the Presbyterian manse, which can just be seen in the distance on the south side. Hungerford Road was named after Hungerford Crewe (1812–94), the third Lord Crewe, who owned much land in the area.

16. LIVERPOOL BRIDGE LOOKING WEST, c. 1962

The block of property, between Earle Street and Liverpool Street, was built by the LNWR, and contained the Mechanics' Institution, shops and the railway laboratories. The latter, established in 1864, were the only railway-controlled chemical laboratories in the UK. Ramsbottom was the moving spirit behind them as he needed the speedy analysis of steel smelted at his newly erected steel works adjacent to Richard Moon Street. Samples of the town's water supply were also regularly examined for bacterial contamination, along with such diverse products as eggs, sausages, milk, paint and blacklead for the LNWR Hotel and Stores departments. The block was demolished in the sixties, providing a more attractive approach to the town centre and, much later, an alternative site for the war memorial.

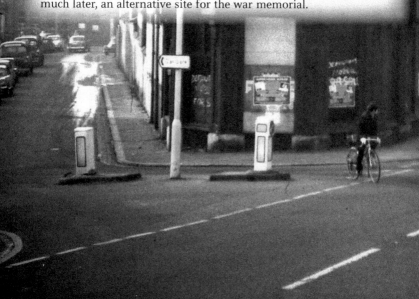

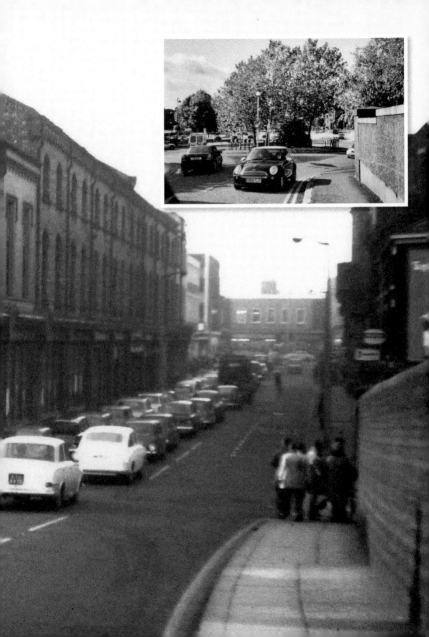

17. JUNCTION OF PRINCE ALBERT WITH EARLE STREET, c. 1880

Much of this building was the Mechanics' Institution (MI), which, for almost a century, acted as the social centre for the town. It contained many rooms including a gymnasium, newsroom, library, a bowling alley and a specification room. Regular classes were held in subjects that related to mechanical engineering. Some of the rarer Nonconformist religious denominations aired their doctrines in a hired room at the MI, as they sought to establish a base in the town. Unlike today's social facilities, money for maintenance of the MI was rarely a problem as it was supported by the LNWR, through the intervention of Webb. When it was demolished a lawned area was created that allowed a far better perspective of the market hall and municipal buildings.

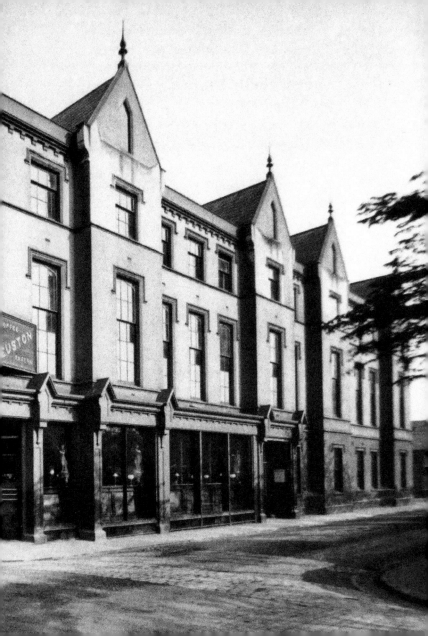

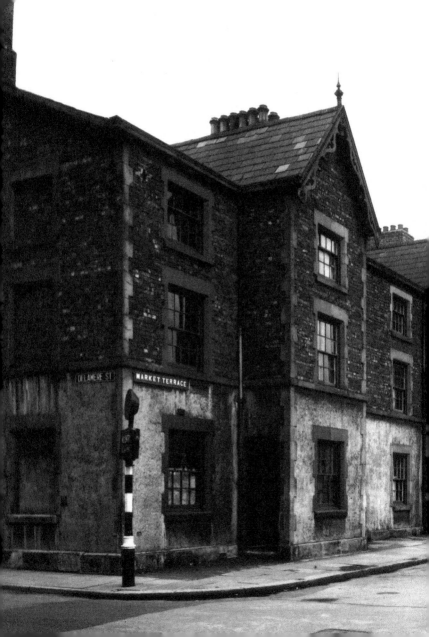

18. MARKET TERRACE LOOKING NORTH, c. 1950

For over 100 years the centre of Crewe had much low-rated terraced housing. Leonard Reeves, the borough surveyor in 1950, claimed that redevelopment was undertaken in the nick of time. As Crewe was ripe for this improvement, he was keen that all the profit should go to the corporation and not to private speculators. Consequently, the block of Victorian property to the west of Market Terrace that contained about eight small, low value shops, along with approximately 170 domestic dwellings, was purchased in order to facilitate a bus station, wider road and a shopping centre. The results of Reeves' planning can be seen in the area today, though after the passage of fifty years further development is planned.

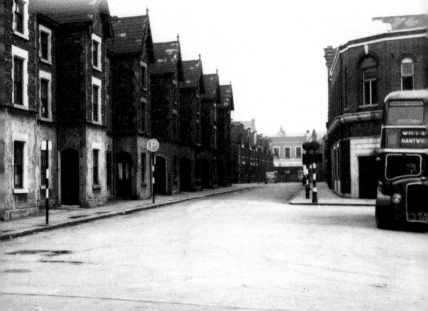

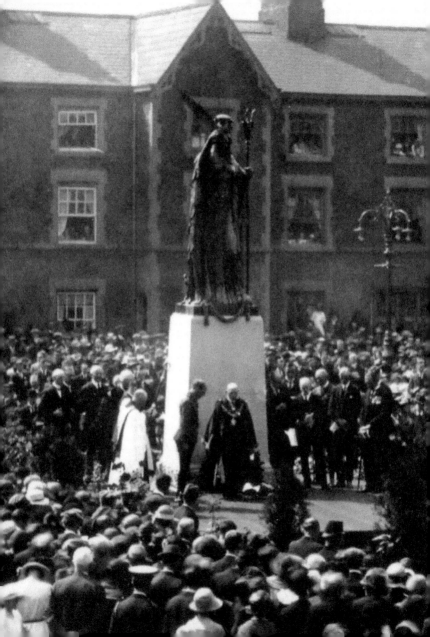

19. UNVEILING CREWE'S WAR MEMORIAL, JUNE 1924

Just over one week after the fighting stopped, in November 1918, the town council, along with the LNWR, were considering widening the Valley Brook and constructing a walkway from the town centre to the Queen's Park as a memorial. When the cost was found to be too great, alternative schemes included a new ward at the hospital, twelve memorial houses, a large public hall or a combined concert hall, canteen and public baths. After consideration, all of these were dismissed in the face of a proposal by HPM Beames for a sculpture on Coppenhall Terrace. A bronze of Britannia, designed by W. Gilbert of Birmingham, was chosen. This was erected on the Market Square, staying there for eighty years, until its removal (with some controversy) to the Municipal Square.

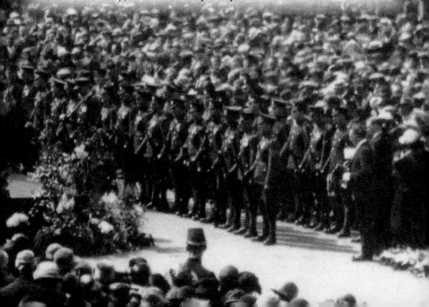

20. THE MARKET SQUARE LOOKING SOUTH ALONG COPPENHALL TERRACE

In the early days of Crewe, the paved, open space served as a market until John Hill built the market hall in Earle Street. This space was given to the town, in 1893, by the LNWR. Behind the trees on the east of Coppenhall Terrace are the LNWR 'block houses' that were the only 'back-to-back' houses in the town. They were built in blocks of four with one door to each house. The dwellings attached to those in the Terrace had their doors in Sandon Street. Sometimes, terraced houses, separated by a narrow alley at the rear, are mistakenly termed 'back-to-back' houses. On the south-east corner of the Square is the District Bank built by Cotterill, a Crewe builder, in 1879.

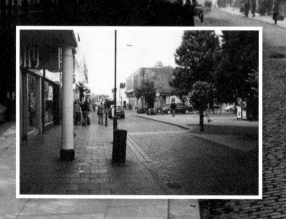

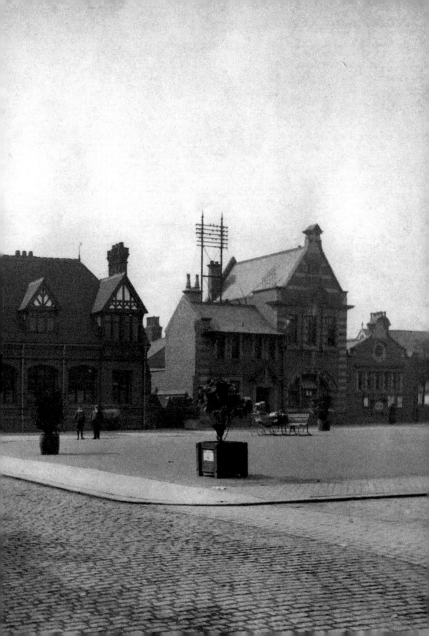

21. EARLE STREET JUNCTION WITH MARKET STREET, c. 1953

From this view, something of the urgency for a programme to deal with traffic congestion can be gained. It might seem incredible, but Market Street had already been widened, some sixty years earlier. The building on the west side of Market Street, nearest to the camera, is the Red Bull public house, one of the first pubs in Crewe, which, according to the diary of the Primitive Methodist preacher, Thomas Bateman of Chorley, was almost completed by the end of July 1843. Many bicycles are in evidence on Market Street demonstrating that Crewe was, at one time, a cycling town.

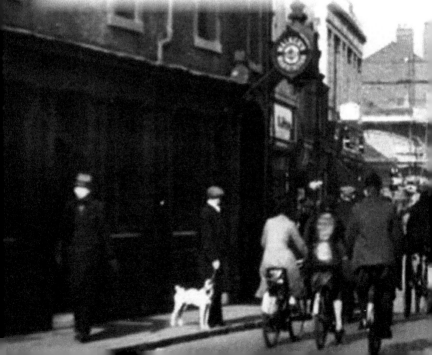

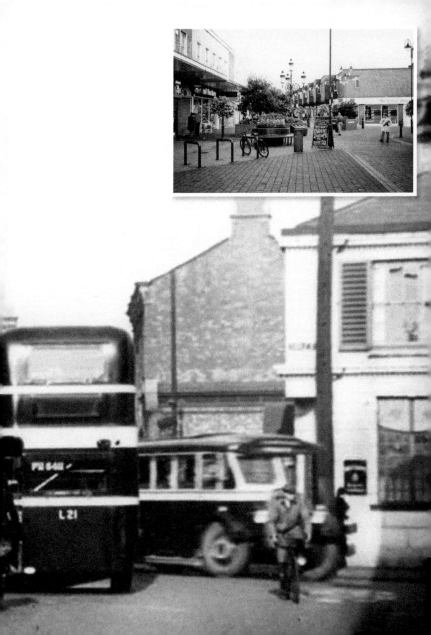

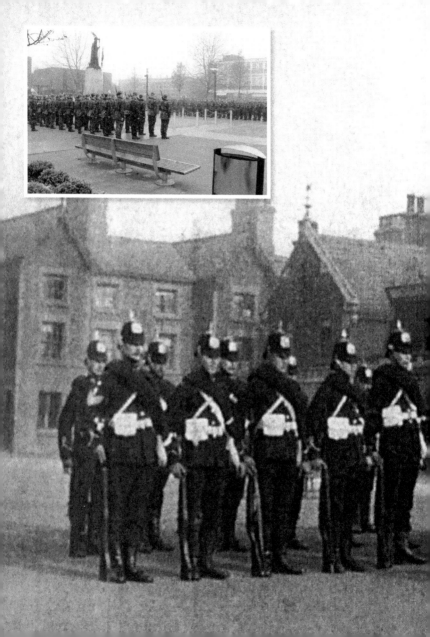

22. MILITARY PARADE ON THE SQUARE, c. 1902

Not only are these images separated by over a century, the squares, where the soldiers are parading, are some 200 m apart. The earlier view is of some of the 2nd Cheshire Engineer (Railway) Volunteers assembling, before leaving for Aldershot. The LNWR, at Crewe, had a long tradition of encouraging military volunteers, stretching back to at least 1864, with the formation of the 36th Cheshire Rifle Volunteers. After gaining around 400 recruits it was disbanded in 1880, only for Webb to form the 2nd Cheshire Engineers seven years later. It was this group of soldiers that saw service in South Africa. Changes in dress and weapons can be seen when, in November 2008, the 1st Battalion Mercian Regiment (Cheshires) received the freedom of Crewe on a raw and foggy Municipal Square.

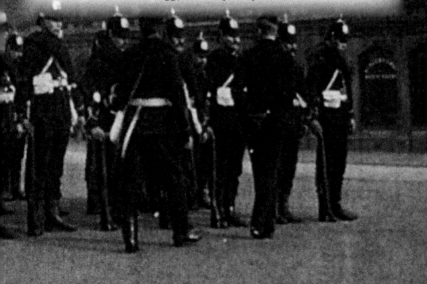

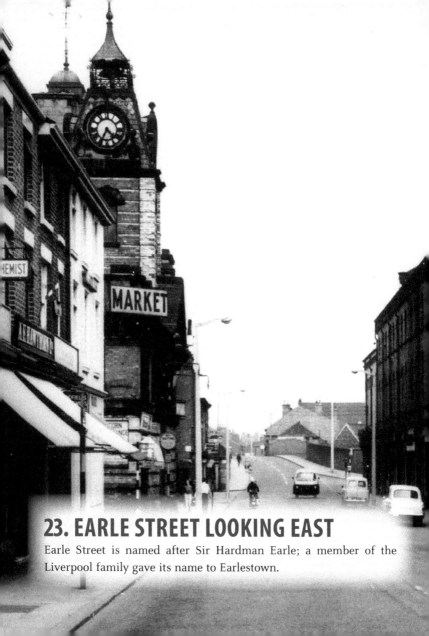

23. EARLE STREET LOOKING EAST

Earle Street is named after Sir Hardman Earle; a member of the
Liverpool family gave its name to Earlestown.

24. JUNCTION OF HEATH STREET AND HILL STREET LOOKING NORTH, c. 1920

Heath Street, originally Russell Street, was so named by the prominent Liberal and Primitive Methodist, Samuel Heath. He, along with his cousin Martin, had inherited much of the town centre land, becoming rich in the process. At the north end of Hill Street can be seen the wall of the Presbyterian church of England, built in 1862, and known as the 'Scotch church' as a large proportion of the members were Scottish. Around 1920, a large room was created in the upper storey of the property, along the north side of Heath Street, which was utilised as the Astoria Dance Hall, in 1945. When the buildings were demolished, in the 1970s, it became an additional site for the market.

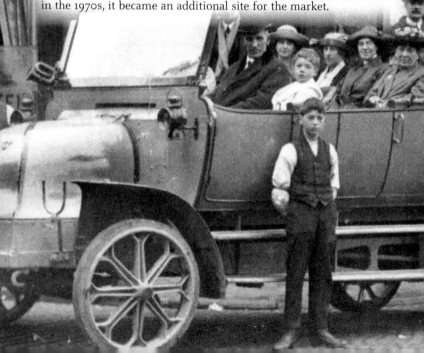

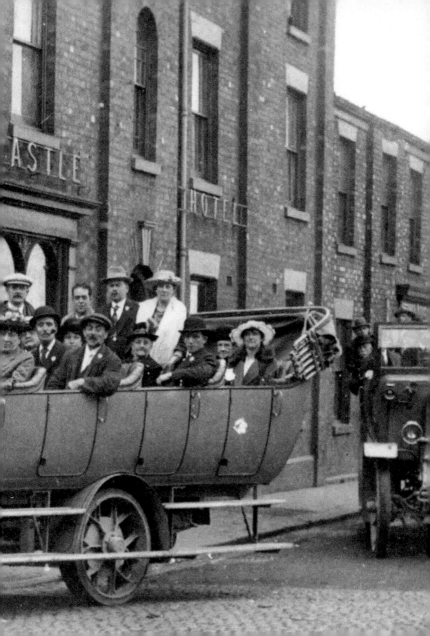

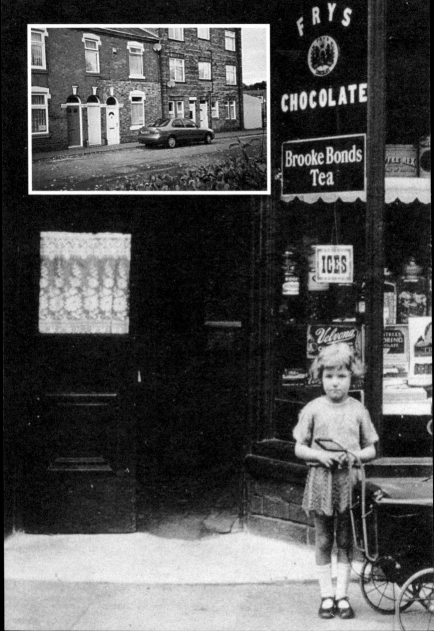

25. GOSLING'S SHOP, MARKET STREET, c. 1925

With the advent of supermarkets, easy transport and freezers, the need for small shops has consistently declined, meaning that many have been converted back into full domestic use. In Victorian and Edwardian Crewe many houses in side streets, especially at junctions, had the front room turned into retail outlets to supply groceries, perishables and sweets to neighbouring families. Mrs G. Gosling, who owned this shop, made her own ice cream in a room at the rear, with materials supplied by Williams Bros Wholesale Warehouse, in Furber Street. In front of the shop, with her doll's pram, is Freda Gosling, who died in 2008. The adjacent three-storey property, now restyled into an apartment block, was one of Crewe's well used, Victorian lodging houses.

ury's Chocolates · · Cadbury's Chocolates

26. BROAD STREET REACHES CROSS GREEN LOOKING EAST, *c.* 1900

Cross Green is a junction of four old roads. North along Stoneley Road, west down North Street (King Street until 1892), east to Sydney, via Remer Street (Maw Green Road), and south along Broad Street. This was the most populated area of Coppenhall until the Grand Junction built its settlement. Maw Green Road boasted the first Nonconformist place of worship in the parish, when a Wesleyan Methodist chapel was opened in 1829. This spot was also the site of the celebrated Coppenhall Spa, an ill-fated attempt to outflank Harrogate's medicinal waters. In 1872, the long arms of the Crewe Co-operative Society opened its sixth branch in Broad Street, or High Street as it was called then.

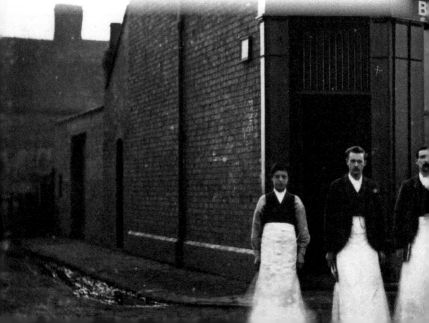

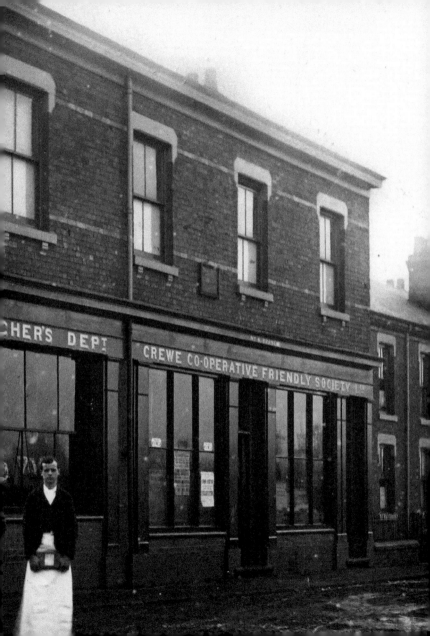

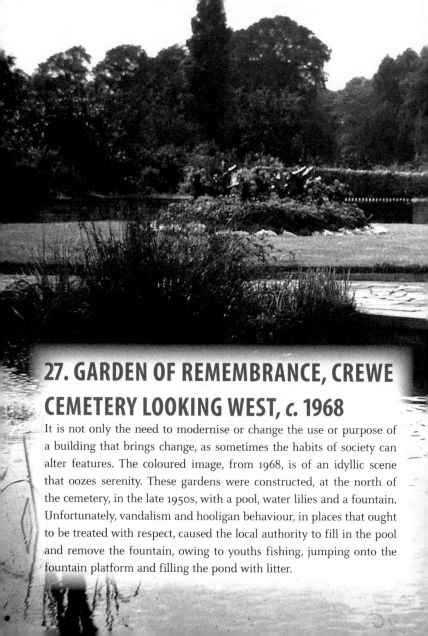

27. GARDEN OF REMEMBRANCE, CREWE CEMETERY LOOKING WEST, c. 1968

It is not only the need to modernise or change the use or purpose of a building that brings change, as sometimes the habits of society can alter features. The coloured image, from 1968, is of an idyllic scene that oozes serenity. These gardens were constructed, at the north of the cemetery, in the late 1950s, with a pool, water lilies and a fountain. Unfortunately, vandalism and hooligan behaviour, in places that ought to be treated with respect, caused the local authority to fill in the pool and remove the fountain, owing to youths fishing, jumping onto the fountain platform and filling the pond with litter.

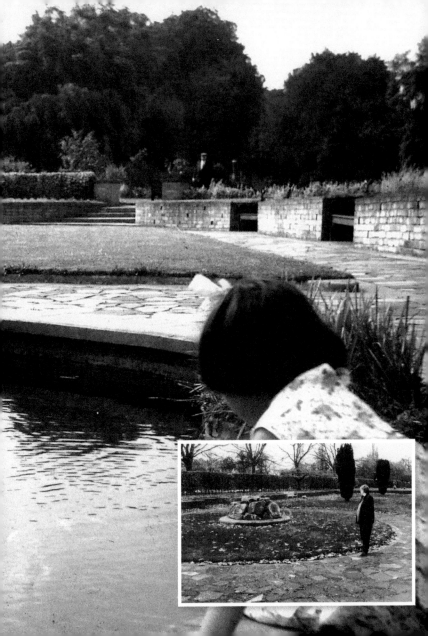

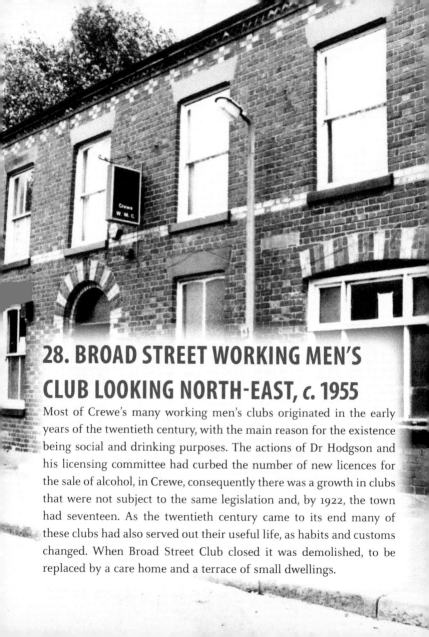

28. BROAD STREET WORKING MEN'S CLUB LOOKING NORTH-EAST, c. 1955

Most of Crewe's many working men's clubs originated in the early years of the twentieth century, with the main reason for the existence being social and drinking purposes. The actions of Dr Hodgson and his licensing committee had curbed the number of new licences for the sale of alcohol, in Crewe, consequently there was a growth in clubs that were not subject to the same legislation and, by 1922, the town had seventeen. As the twentieth century came to its end many of these clubs had also served out their useful life, as habits and customs changed. When Broad Street Club closed it was demolished, to be replaced by a care home and a terrace of small dwellings.

29. WEDGWOOD METHODIST CHAPEL, HEATH STREET LOOKING WEST, *c.* 1910

This chapel was built by the Primitive Methodists in 1865, replacing one on the same site erected ten years previously. Such rapid rebuilding is indicative of the virility of this denomination in Crewe. It was named Wedgwood in honour of John Wedgwood, a veteran itinerant preacher, who had settled in Albert Street. Wedgwood chapel, capable of seating almost 1,000 persons, was head of Crewe No. 1 PM circuit, and had a reputation for organising choir concerts. Some of its many rooms were used by branches of the AEU and other societies. At one end of its schoolroom was the highest stage in the whole of Crewe. The site is now a car park that doubles as an overflow marketplace.

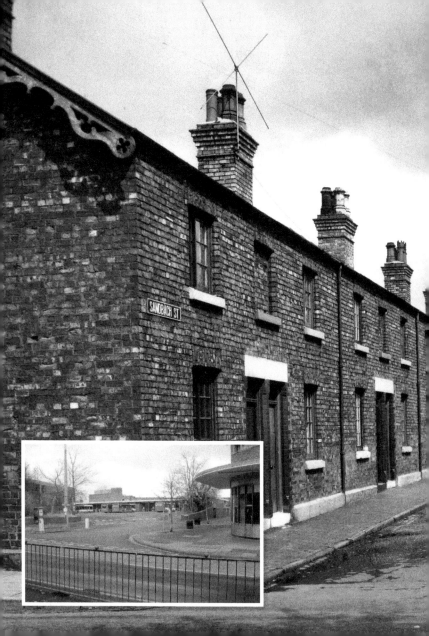

30. LOOKING NORTH ALONG SANDBACH STREET FROM DELAMERE STREET, *c.* 1950

As Crewe emerged from the Second World War it was desperately short of a recognisable shopping centre. The few chain stores, such as Woolworths and Marks & Spencer, that had settled in the town were mainly on the short stretch of Market Street, between Victoria Street and the square. In addition, a bus station was urgently needed to allow the square to return to its original function as an open space for public use, rather than a terminus for public transport. Sandbach Street, a narrow Victorian thoroughfare, was demolished along with similar property, to create the bus station and refreshment room. Its main entrance, for pedestrians from the town centre, was through the Royal Arcade.

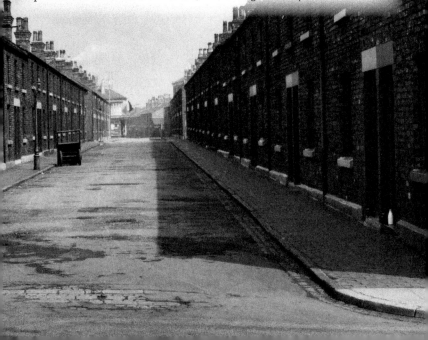

31. LOOKING EAST ALONG DELAMERE STREET, *c.* 1950

If the earlier scene was in colour it would be almost idyllic, with the trees in full leaf and no litter or graffiti to mar the view. The streets of houses to the north of Delamere Street were erected and named by the LNWR. Lawrence Street, bearing the name of a director of the Grand Junction Railway Co., can be seen quite clearly. The tree nearest to the camera (a horse chestnut) is in the garden of a villa residence occupied by one of the company's higher officials. All of the properties on both sides of the street were removed to create space for the bus station, Delamere House, and a car park.

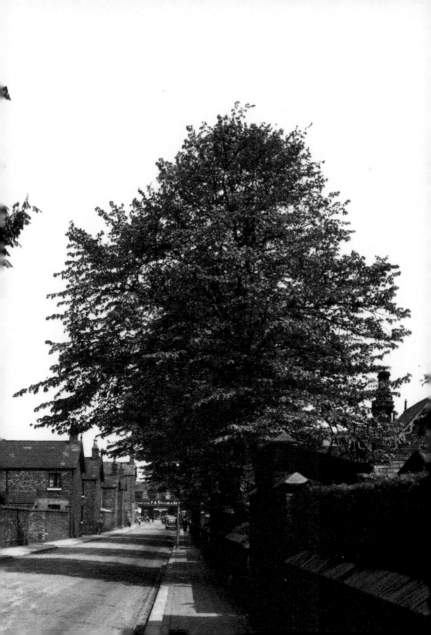

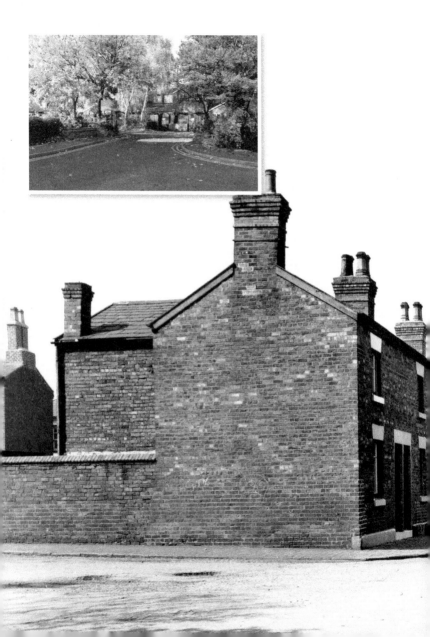

32. LOOKING NORTH AT THE JUNCTION OF LAWRENCE STREET WITH WELLINGTON SQUARE, *c.* 1950

Most of the property, seen in this picture, went in the Central Town Improvements in the 1950s, including the section of Ludford Street that can be seen on the north side of Victoria Street. The Star Inn is visible on the corner of Ludford Street. The property that fronted the western end of Victoria Street remained largely untouched, as can be seen in the later picture that was viewed from a slightly different position. Autumn tints on the trees mask the backs of the houses on 'Gaffer's Row'. Wellington House, built nearby, retains the link with the victor at Waterloo honoured by a street name in Victorian Crewe, as in many other Victorian towns.

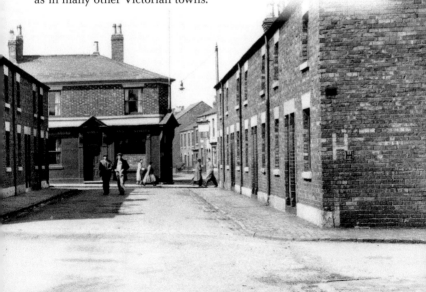

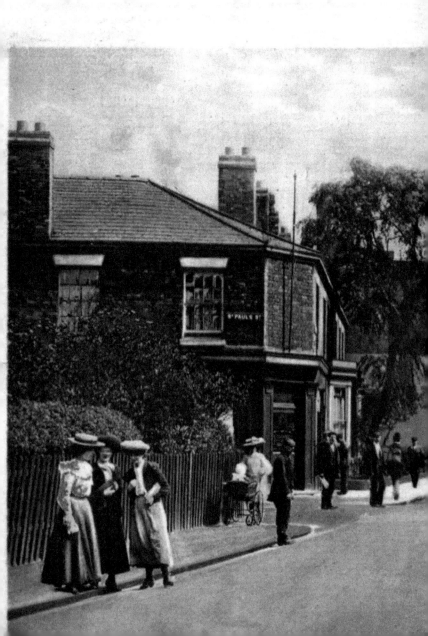

33. VICTORIA STREET JUNCTION WITH HIGHTOWN LOOKING EAST, *c.* 1900

Very few alterations have occurred in the century that separates these two views. They have been included to demonstrate, yet again, that some areas of the town have not been subject to great changes. Gatefield House, the large dwelling on the east corner of Gatefield Street, was built by Dr Richard Lord, the brother of John who built Havelock House. Richard followed his brother into Crewe, to practice medicine from Gatefield House, until he sold out to Dr William Hodgson, who later built Helmsville. Beyond Gatefield House is Gaffer's Row where railway foremen lived. With only eight dwellings in this terrace, and at least forty-nine foremen, most of them lived elsewhere in the town.

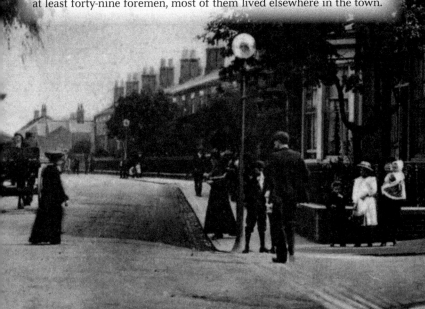

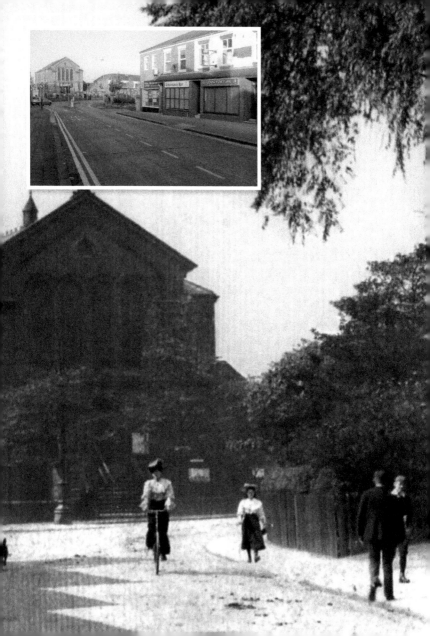

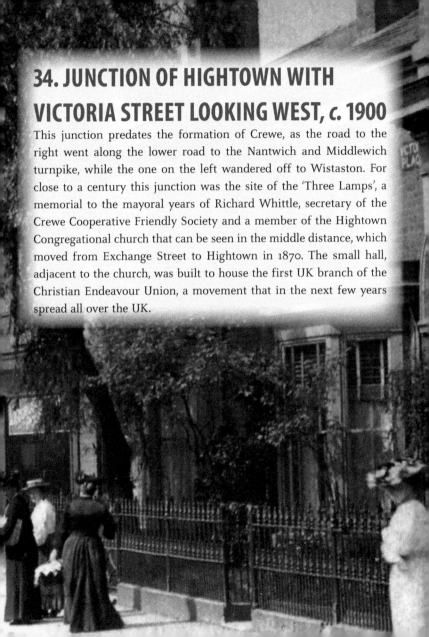

34. JUNCTION OF HIGHTOWN WITH VICTORIA STREET LOOKING WEST, c. 1900

This junction predates the formation of Crewe, as the road to the right went along the lower road to the Nantwich and Middlewich turnpike, while the one on the left wandered off to Wistaston. For close to a century this junction was the site of the 'Three Lamps', a memorial to the mayoral years of Richard Whittle, secretary of the Crewe Cooperative Friendly Society and a member of the Hightown Congregational church that can be seen in the middle distance, which moved from Exchange Street to Hightown in 1870. The small hall, adjacent to the church, was built to house the first UK branch of the Christian Endeavour Union, a movement that in the next few years spread all over the UK.

35. HILLOCK HOUSE, HIGHTOWN, *c.* 1920

Hillock House was the home of Thomas Beech, who farmed this area when the Grand Junction Railway came to Monks Coppenhall. Alderman Heath wrote that this house should be 'preserved for all time as a memorial of early Crewe'. Sadly, this did not happen, for it went the way of many of the town's buildings, being demolished shortly after the First World War. The site remained unused until the council laid out a garden to commemorate the jubilee of the town's incorporation that was opened by Sir William Hodgson, of West Street. In 2006, a tree was planted to note the passing of Mike Langley, three time national sports journalist of the year, who, when he was young, lived around 50 yards away. It is our loss that death prevented him from finishing a Crewe-based novel.

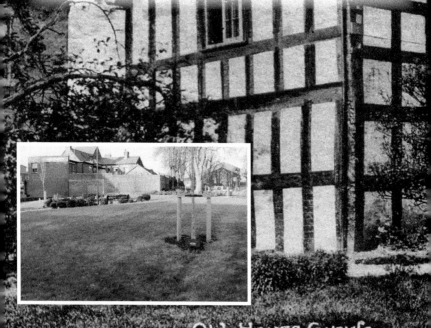

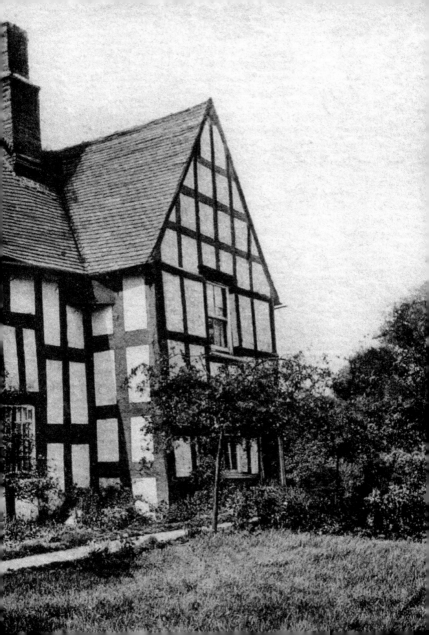

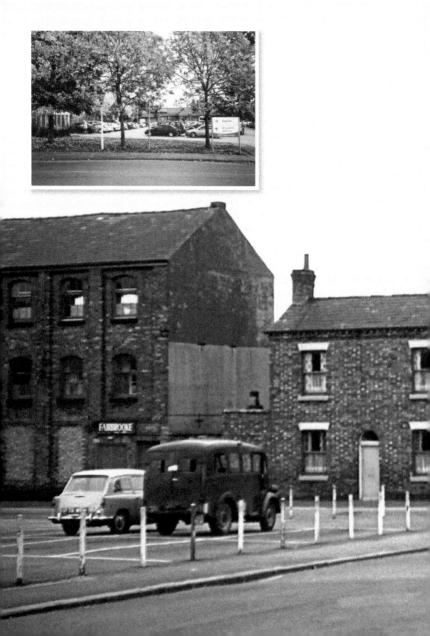

36. FURBER STREET JUNCTION WITH BEECH STREET LOOKING EAST, *c.* 1965

It is impossible to reconcile these two images, as there is nothing to use as a reference point, owing to the redevelopment of the area in the years after 1950. Beech Street gained its name from Thomas Beech, a farmer, at Hillock House on Hightown who farmed the area when the Grand Junction Railway established the town. Furber, after whom Furber Street was so called, was Col Henry Meredith's land agent. The three-storey building in Furber Street was the wholesale warehouse of Williams Bros, who vacated this structure to move to one on the Weston Road Industrial Estate. Autumn leaves on the town centre trees provide an attractive frame to this scene.

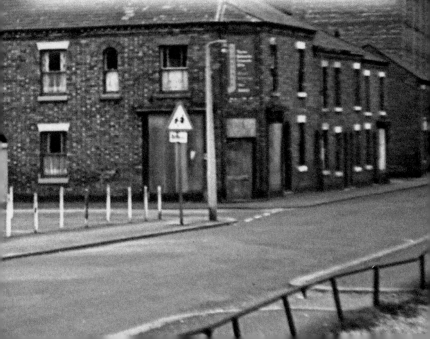

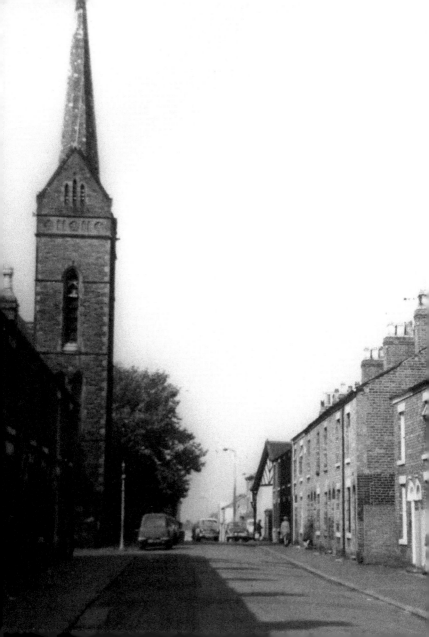

37. JUNCTION OF ALBERT STREET WITH HIGHTOWN LOOKING WEST, *c.* 1960

A wider road and a few trees have replaced the terraced dwellings that filled this area for 100 years. As this is the approach to the town centre it gets very busy at times. St Paul's church, a 'company church', lost its spire in the years after the Second World War. The Revd A. H. Webb, brother of the chief mechanical engineer, was the vicar there from 1879 to 1910. Albert Street was where Ada Nield lived, who, as students of Crewe's history will know, was a worker in a sewing factory sacked for writing letters to the *Crewe Chronicle* in 1894 under the pseudonym 'Crewe Factory Girl'. A terrace of about ten houses is all that is left of this street.

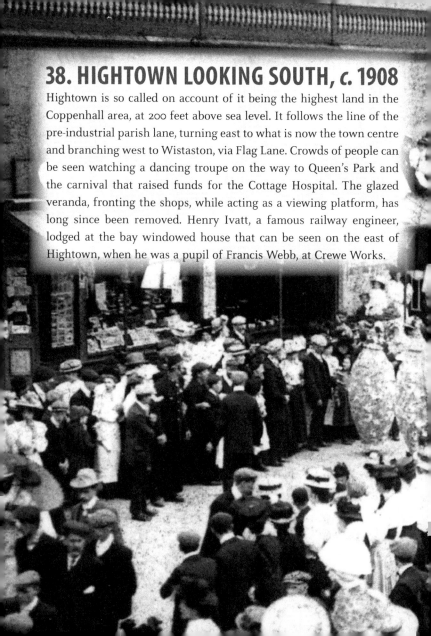

38. HIGHTOWN LOOKING SOUTH, c. 1908

Hightown is so called on account of it being the highest land in the Coppenhall area, at 200 feet above sea level. It follows the line of the pre-industrial parish lane, turning east to what is now the town centre and branching west to Wistaston, via Flag Lane. Crowds of people can be seen watching a dancing troupe on the way to Queen's Park and the carnival that raised funds for the Cottage Hospital. The glazed veranda, fronting the shops, while acting as a viewing platform, has long since been removed. Henry Ivatt, a famous railway engineer, lodged at the bay windowed house that can be seen on the east of Hightown, when he was a pupil of Francis Webb, at Crewe Works.

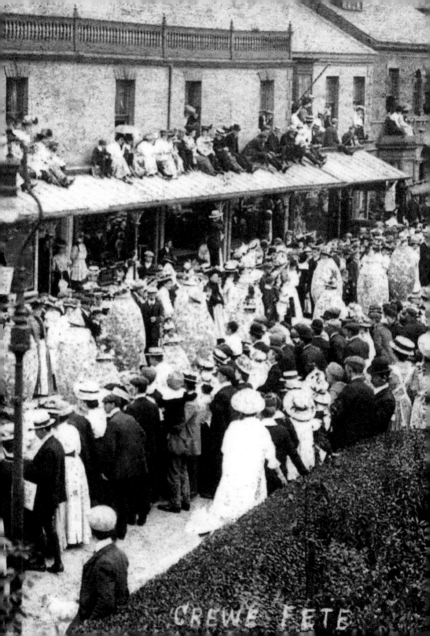

CREWE FETE

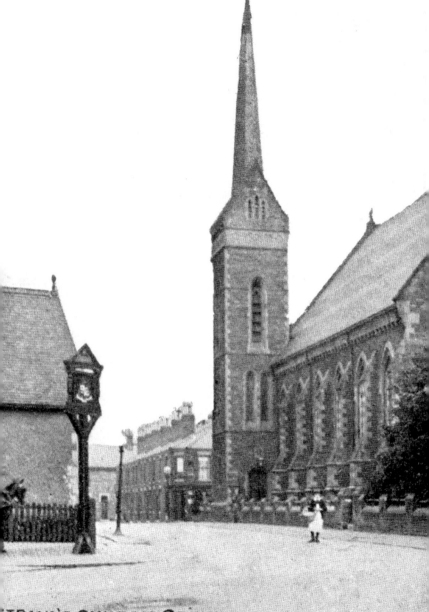

ST PAUL'S CHURCH, CREWE.

39. ST PAUL'S CHURCH AND THE CHETWODE ARMS LOOKING EAST ALONG ALBERT STREET, *c.* 1906

Demolition of the Chetwode Arms to allow for road widening caused much controversy, as parts of it were older than the town. When the bishop, who performed St Paul's consecration ceremony, first saw the church he is supposed to have compared it to a railway station. Initially, while the Revd J. Ashe was the vicar it was poorly attended. After the Revd A. Webb's arrival, however, the attendance improved overnight. Perhaps the fact that he was the brother of Francis Webb, the chief mechanical engineer of the LNWR, had something to do with it. Having been deconsecrated, it now serves as the headquarters of Crewe Christian Concern.

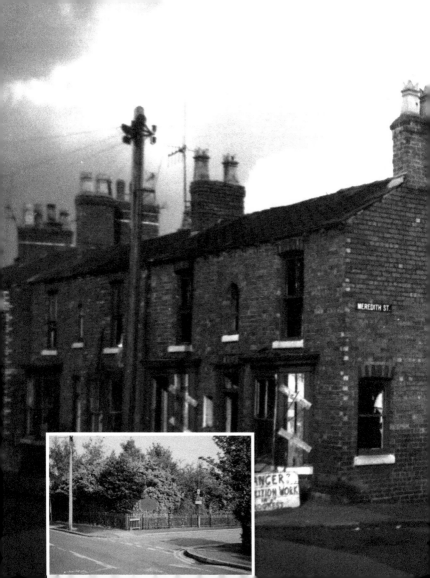

40. JUNCTION OF MEREDITH STREET WITH BROAD STREET LOOKING NORTH-EAST, *c.* 1965

Broad Street was not one of the original roads of pre-industrial Coppenhall, as it was not until the 1860s that this road was constructed, under the name George Street, though, no doubt, there would have been a rough path for the convenience of worshippers at St Michael's church. When the cemetery was opened, in 1872, George Street was renamed Cemetery Road, but another fifty years were to pass before the street became Broad Street, reaching from Hightown to Cross Green. All of this terraced property was cleared to create space for Beechwood Primary School, hidden behind the foliage. Beechwood, opened in 1973, replaced the gaunt three-storey school at the east end of Beech Street.

41. WEST STREET JUNCTION WITH BROAD STREET LOOKING EAST, *c.* 1960

All of these buildings have gone, except the large three-storey house-cum-shop on the corner of Adelaide Street, named and dated 'Tower Buildings 1874', in a panel on the gable. Even the Chetwode Arms, an old pub that can just be seen at the corner of Broad Street, succumbed to the demolition hammer. Adelaide Street was so named after the granddaughter of the Revd J. Ashe, a rich, ex-stockbroker, and first vicar of St Paul's church, who bought land in this area. A Shell garage, with an RAC sign above, was a dwelling house owned by Henry Farrall before he obtained planning permission for a petrol garage in 1927. For many years it boasted a single pump to service vehicles that stopped at the kerbside for petrol.

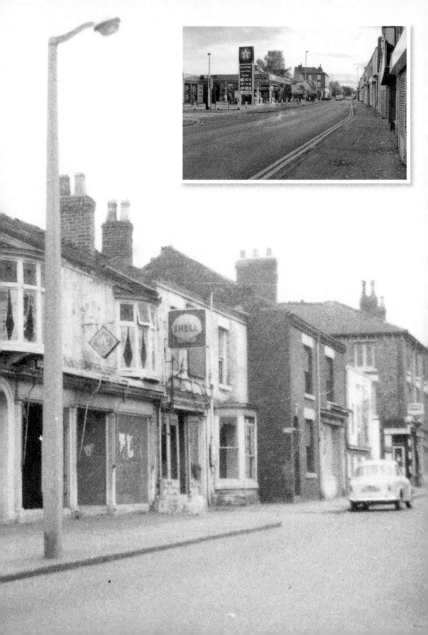

42. THE GRAND CINEMA LOOKING WEST, c. 1930

This cinema, erected on the site of Dr Lowe's house and consulting rooms, was opened in 1922 by the West End Cinema Co., a small group of Crewe businessmen, who were cashing in on the latest entertainment craze. Among them was William Whithoff, a sausage skin manufacturer, whose father had migrated from Prussia to England. As one of Crewe's six cinemas, the Grand faced opposition, especially as it was so far from the town centre. One of the larger houses further down, on the north side of West Street, was 'Belvedere', a young ladies' private school, in the middle years of Victoria's reign. On the corner of Dewes Street, adjacent to the cinema, was one of the many branch stores of the Crewe Co-operative Society.

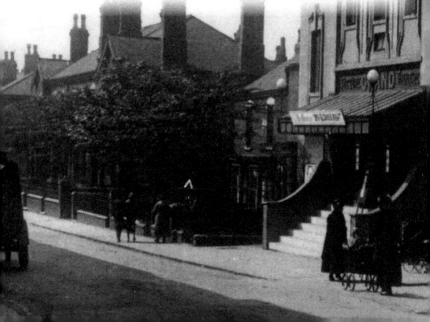

43. GODDARD STREET ENTRANCE TO THE LMS WORKS, *c.* 1930

One of the most dramatic changes to the fabric and economy of Crewe over the last fifty years has been the remorseless decline of the railway works. On acreage that was once devoted to manufacture now stands supermarkets, a medical centre, car parks and domestic dwellings. Immediately through the entrance, erected by the LNWR in 1874, were the axle forge, brass foundry, tender shop and coppersmiths. As the land was once owned by John Hill, the railway contractor, this thoroughfare was once known as Hill Street West. Later, owing to that name being in use in the centre of the town, it became Goddard Street, a change that kept it in the family as Goddard was Hill's son-in-law.

44. ROLLS-ROYCE FACTORY, *c.* 1949

Building started on this factory in the summer of 1938, though it was not officially opened until July 1939, by which time it was manufacturing Merlin engines for the War Department. A Rolls-Royce Silver Dawn, launched in 1949, can be seen at the front of the main administration building. On the later image can be seen a Bentley 'R' type, which was manufactured at Pym's Lane from 1946. Note the disappearance of the lanterns on either side of the entrance. Other alterations include the glass canopy and automatically opening doors. More important is the replacement of 'Rolls-Royce' by 'Bentley Motors', signifying the change in ownership that occurred when the marques were sold off, leaving Bentley as the sole maker of cars in Crewe.

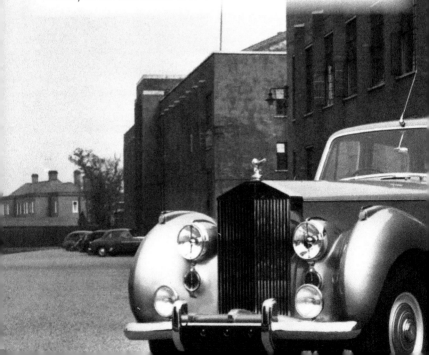

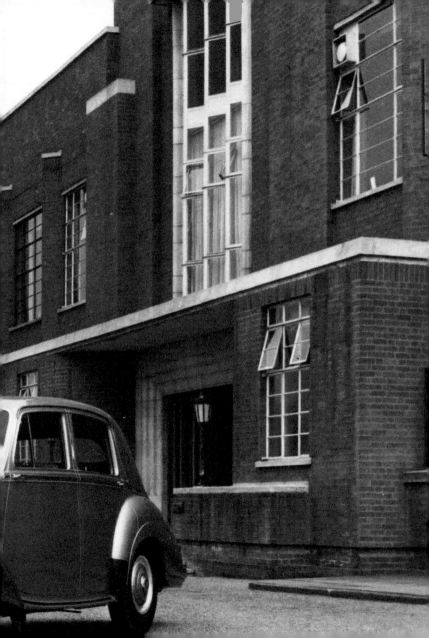

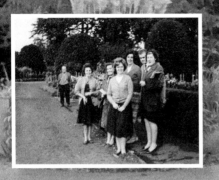

45. QUEEN'S PARK BOWLING GREEN LOOKING NORTH, *c.* 1963

Not only has the fabric of the town been affected by the passage of time. A putting competition was the impulse for this gathering in the park in the early 1960s (*inset*). A man, standing apart from the group, was not a competitor, and is not included in the retake. From left to right the contestants are June Tweats, Rose Ollerhead, Ruth Grimshaw, Graham Harvey and Alice Jones.

46. QUEEN'S PARK PAVILLION, c. 1910

Queen's Park, given to people of Crewe by the LNWR, during the year of Webb's mayoralty, was not officially opened to the public until 1888. Oval in shape, the perimeter fence encloses 45 acres of trees, grass, flowers, shrubs and a lake. The pavilion on the earlier image had to be rebuilt after a disastrous fire, unfortunately in a totally different style. Webb paid the major portion of the cost of the original pavilion out of his own pocket. The memorial commemorates Crewe's contribution to the Boer War of 1899–1902. Of the 285 men that served, 26 of them paid the ultimate price.

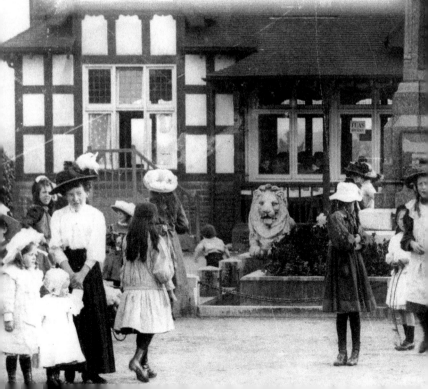

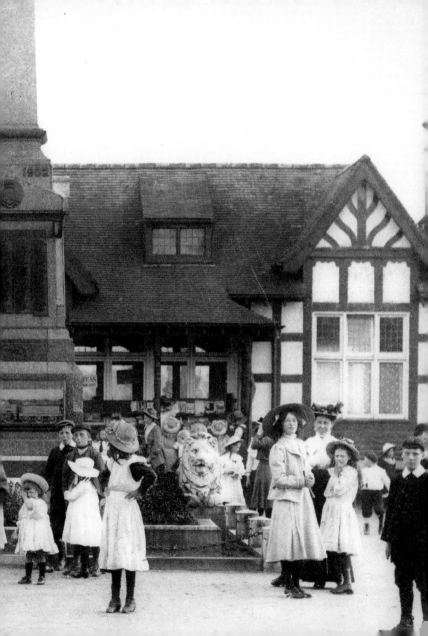

ACKNOWLEDGEMENTS

In compiling this work I am grateful to the many students of the town's history, especially the indefatigable Professor W. H. Chaloner, a worthy candidate for further recognition, from the borough of his birth. Others from the past that must be mentioned are the reporters and editors of Crewe's local newspapers who recorded events and people in great detail; and Albert Hunn, a Crewe man who quietly photographed many of the changes that occurred in his lifetime. Collective thanks must also be made to Colin and Mary Maclean, Susan Chambers, Andrew Turner, Mick Gilsennan and the members of the town's Historical Society and the South Cheshire Family History Society for their interest in the town's history. As always, I must record my appreciation to my wife who patiently accepts my visits to libraries and archives, even accompanying me on many occasions, which must surely be consideration and help beyond that required by the marriage service.